Kinetic Flying Sculptures

Ondrej Mitas

© 2018 Ondrej Mitas. All rights reserved.
ISBN 978-1-387-80713-0

An alchemy of time

This is a book of my flying kinetic sculptures. They are made to look beautiful in flight. In fact, while the photos portray them at rest, they are only really complete when they are in flight. They are powered by thin strips of rubber that either catapult them skyward or are wound hundreds of times to power their propellers. Once in flight, these works are not under any kind of human control and can fly wherever air currents take them. The world stands proverbially still as they trace elegant circles overhead. Sometimes they land at my feet, sometimes they land in a tree, and occasionally they are taken by updrafts of warm air high and out of sight.

It is the motion of flight, of something heavier than air nevertheless making its way upward, that creates an alchemy of time, making a moment seem to last forever. By creating such moments, these works are intended not as models of things that fly, but as models of flight itself. My purpose is, using a few simple materials and shapes, to distill flight to its very essence. In the pages that follow, I explain how and why these works are made.

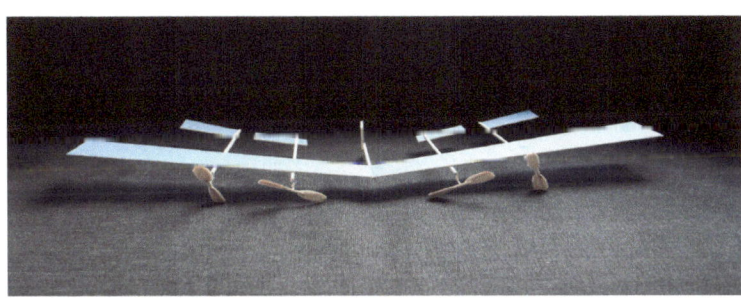

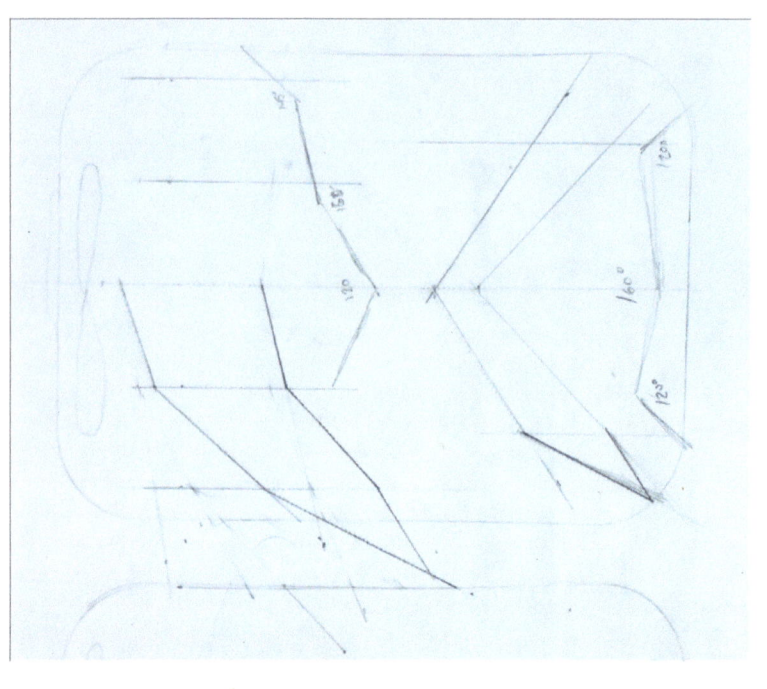

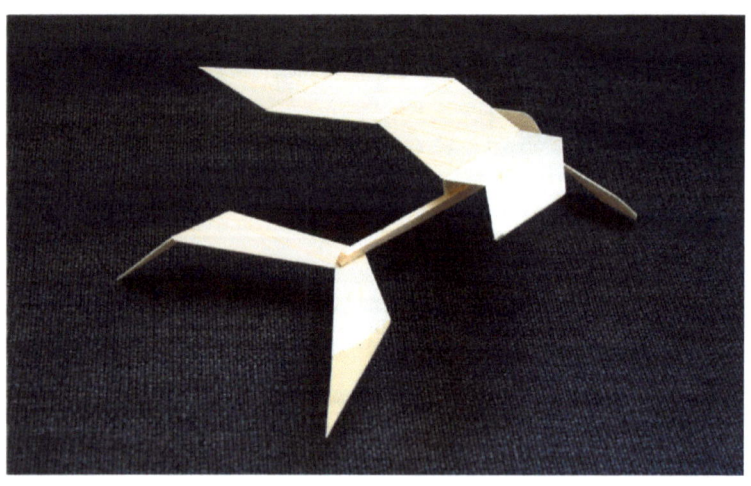

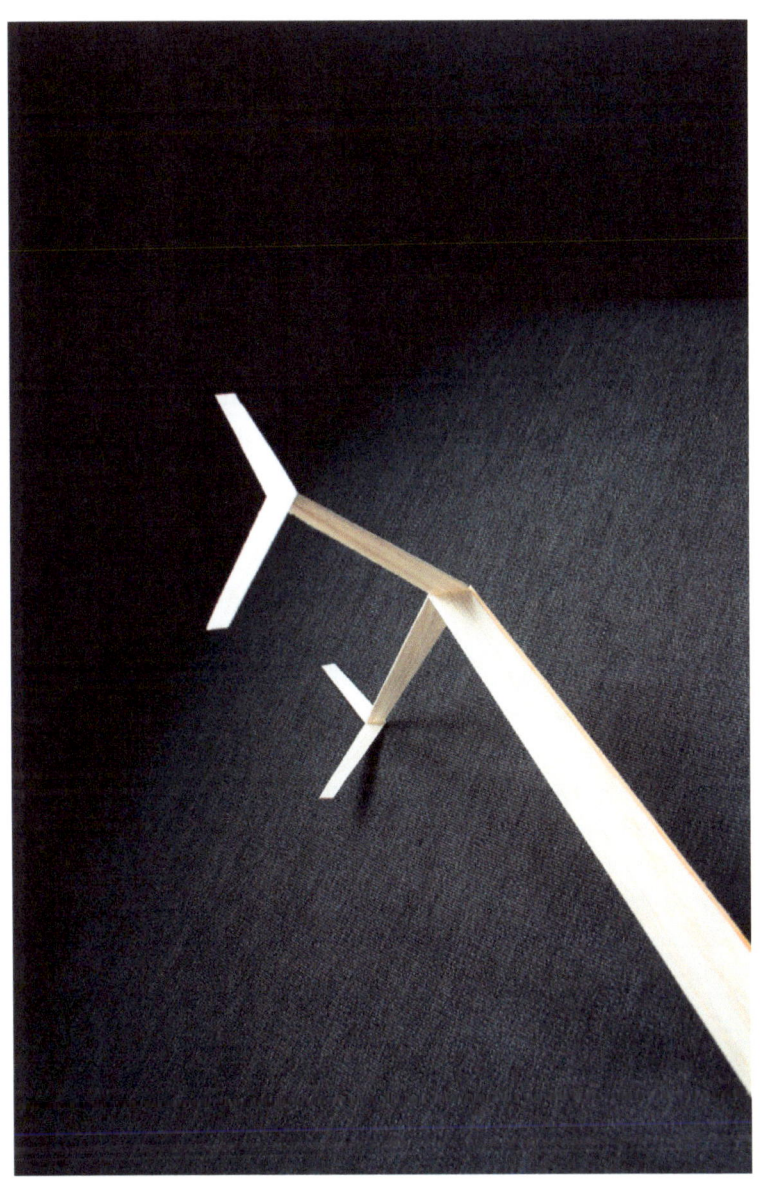

Origins

I spent the first seven years of my life in Bratislava, a fascinating cultural crossroads, during the sunset of Eastern Bloc socialist government. Though taken in 2017, the upper photo pretty much sums up what I remember of my childhood there—the thrill of Mil-8 helicopters briefly appearing between the rooftops of concrete panel apartment blocks. There were other thrills, however, which also led to me to building small things that fly—the toy store in our neighborhood getting a rare shipment of huge, spectacular Revell models of fighter planes, my mom building a smaller one, with its tiny pilot figure, when I was 3, and perhaps most influentially, watching the magical meadow winds lift little Komar flying model airplanes—available even at grocery stores—out of sight.

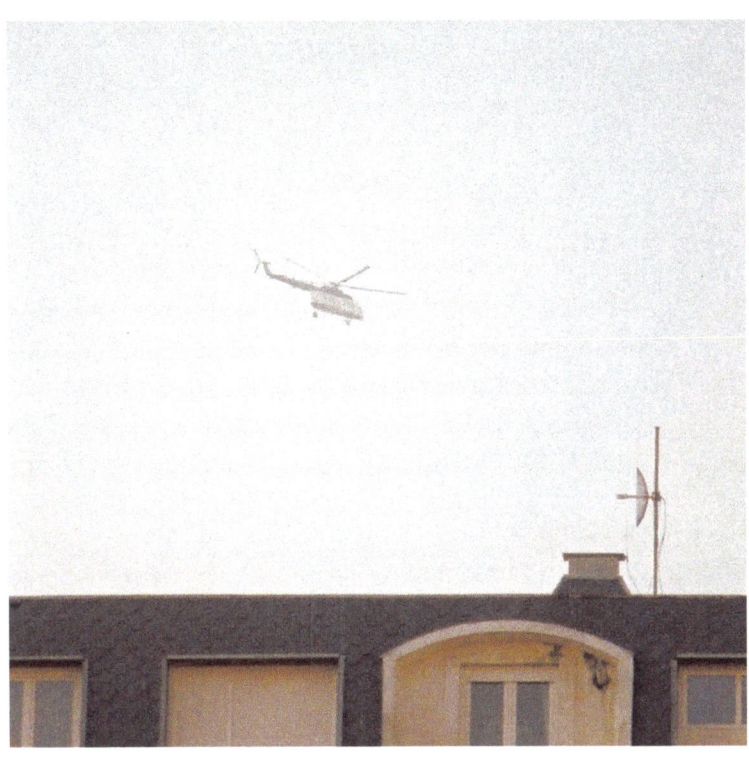
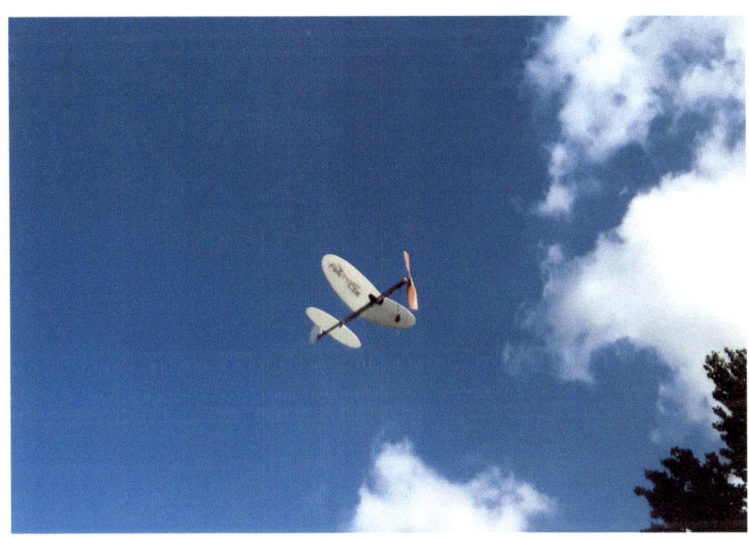

Materials

My works are usually built with four ingredients.
1. Balsa wood, an extremely light and strong hardwood grown in Ecuador that either makes a light wing surface or an very light and rigid structure from just a few thin sticks;
2. Gampi tissue paper, which is made in Japan from a tree fiber that can only be harvested in small quantities, and covers the balsa wood frames with a strong surface;
3. Steel wire, used to form propeller shafts and hooks which hold the strands of rubber that provide power; and
4. Brass tubing, a piece of which holds the steel propeller shaft so it can turn.

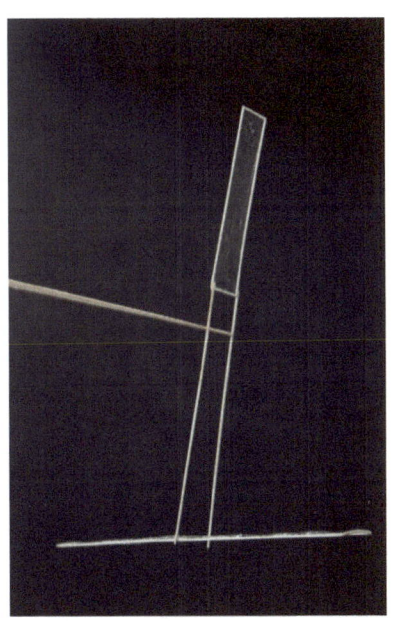

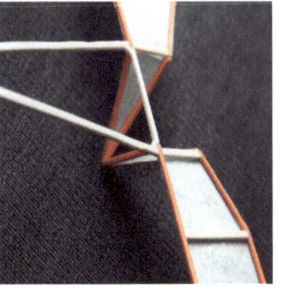
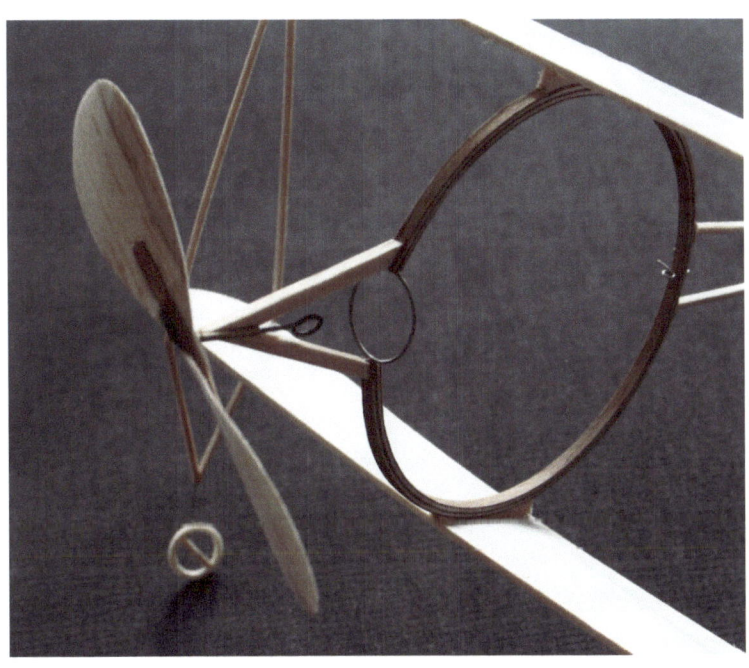

Flight

Some works are simply gliders meant to be released from a high place or shot into the air with a rubber band catapult. Most, however, can rise from my hand or even from the ground high into the air under the power of a spinning propeller. The propeller, in turn, is powered by a thin strip of rubber which is wound 1000-2000 times. This rubber, like the works themselves, is a bit of an esoteric material. It is normally manufactured to create the center of golf balls, although as "solid core" golf balls become more widely used, this nice rubber becomes harder to find.

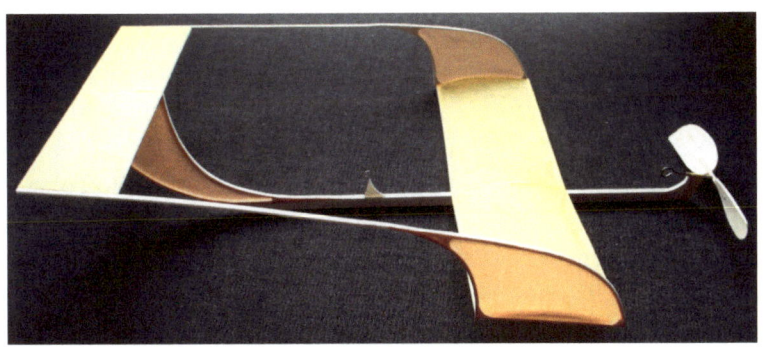

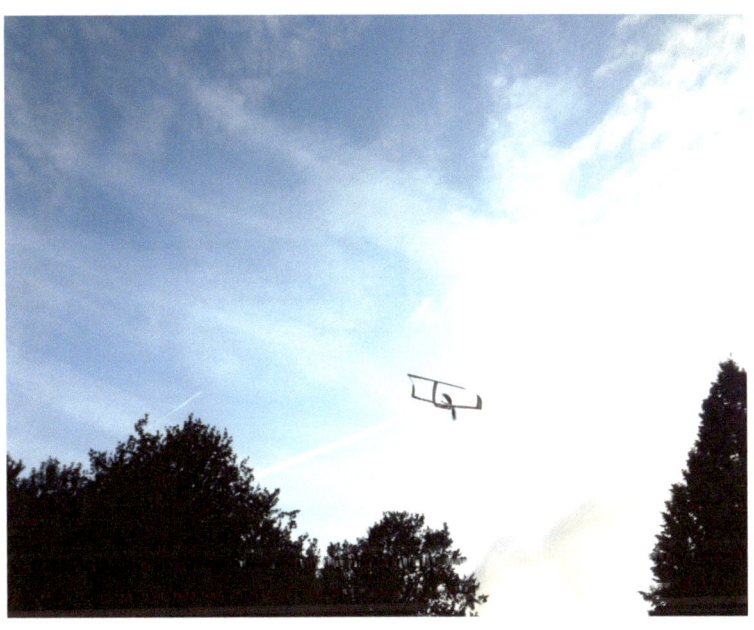

Making

The works begin as an image in the mind. Putting this on sketch paper immediately reveals inevitable practical and construction problems. I try to resolve these problems by forgetting about the idea for a while, rediscovering it in my various tiny notebooks, and just drawing it over and over again. At this point I often give up, but if I manage to solve all the challenges and still like how the design looks, i draw it on parchment in full size, and often with the various parts (wings, tail) in separate places. The point of this final parchment drawing is to provide an actual template to build the work on. It is pinned to a piece of ceiling tile, covered with plastic wrap, and then the wood components themselves are pinned over their actual location on the drawing and glued. Ideally a nice flat component results. The process can then be repeated with these components to build up from the tile in three dimensions.

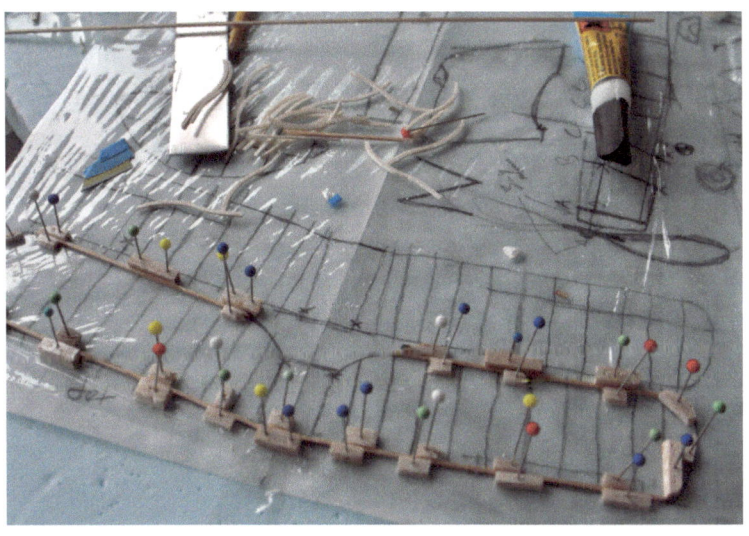

Not model airplanes

Some would call these works model airplanes. They are not—they are not made to emulate any particular dimension of human-carrying aircraft. But there is obviously some connection, which I didn't understand until my wife made a remark when we were walking to the park to fly some of these works. We heard an airplane flying overhead. As I craned my neck to see it, she calmly said,

I can hear the imitators,

as if a small flying object was the "real thing" and a human-carrying aircraft was the model. But this is actually true, in a way. The first human-carrying airplanes flew around 1903, but the first time something looking like an airplane flew under its own power was in 1871, the *planophore* of Alphonse Pénaud. It had a wooden frame covered with paper, and a propeller powered by a tightly wound strip of rubber. Sound familiar? And it was actually an inspiration—but also an important solution to some aggravating design problems—behind many of the first successful human-carrying airplanes. So human-carrying airplanes are, in a way, models of small wooden rubber-powered ones, not the other way around.

And because nature is full of flight, if my works are models of anything, they are models of nature.

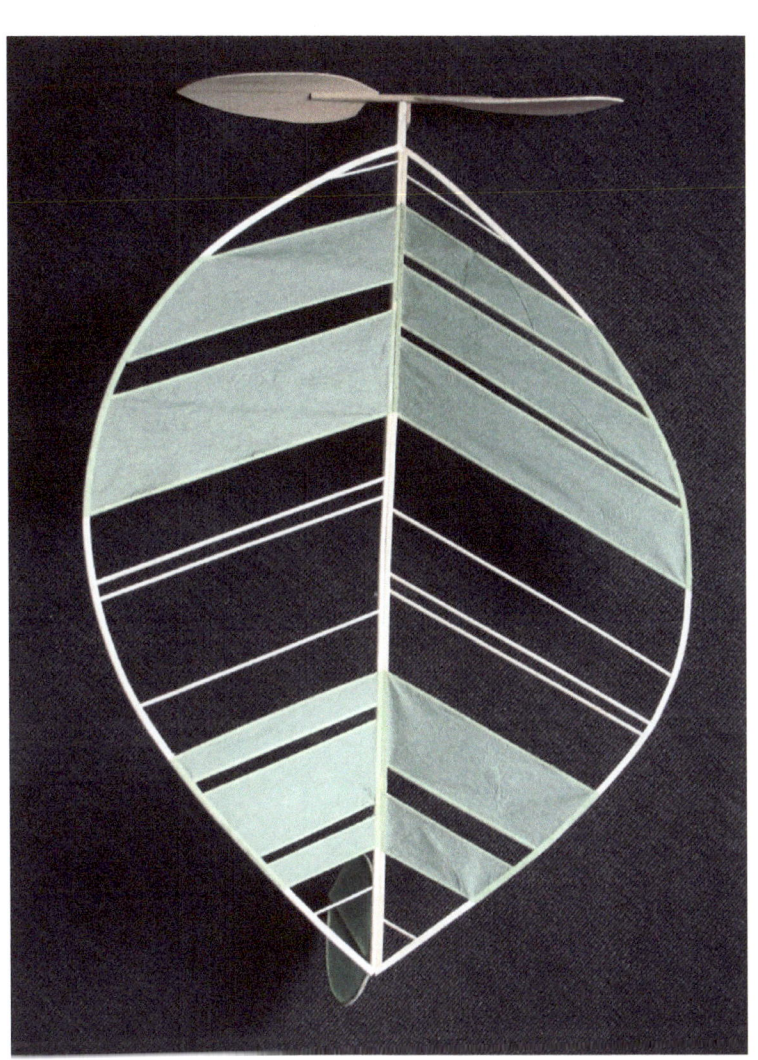

Biophilia

Nature and natural selection have produced treasures of beauty that are sometimes almost too great to comprehend. Taking in these treasures on my walks or bike rides fills me with an irrepressible urge to create. Sometimes I build a form from nature into or around the form of an airplane. At other moments, there is just no way to improve or simplify a simple model of a natural element.

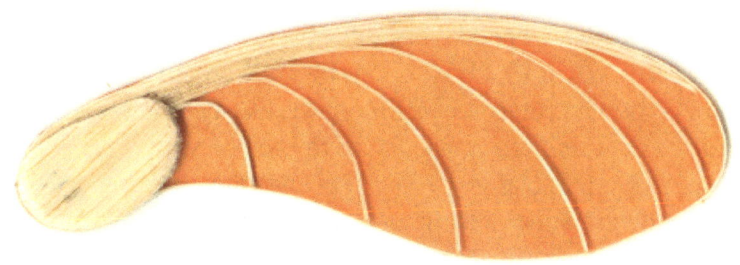

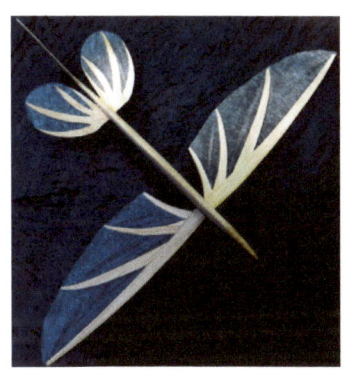
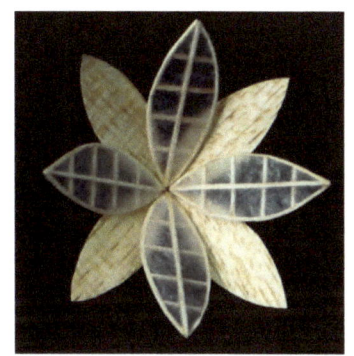

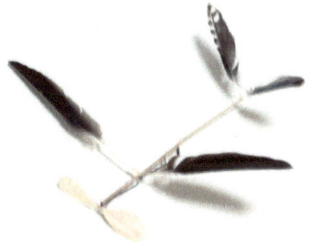
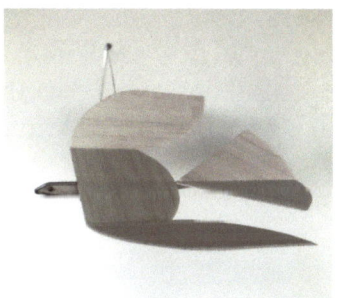

Integration

I have occasionally tried to sell these works, and very occasionally succeeded, but this process does not come naturally, either to the works or to me. For something to be worth money, it has to fulfill a need, like people's need for art to decorate their house or for toys to play with. The works do not make good toys, because they break the moment someone gets the notion to "play" with them. They also don't really fit people's idea of "art," which seems to have two criteria:

1. It hangs flat on a wall, or exceptionally sits durably on a pedestal; and
2. It carries some kind of social prestige.

You might guess that neither of these criteria makes it into my mind when these works are being born. I do try to make them beautiful, so in that sense they could fill the role of decorating a space. Even for this, they are a bit fragile, and difficult to mount. In cooperation with artist Laura Pardo, we came up with the concept of mounting the works in a flying position to the end of a fairly stiff steel wire, the other end of which mounts to the wall. The work can then gently move in a draft as if flying, the wire is unobtrusive, and there is a nice tension from the minimal weight of the works bending the wire just a little. They are still not the most practical decoration, but if they have enough room, it works. For what it's worth, several of the works in this book are still available at this writing.

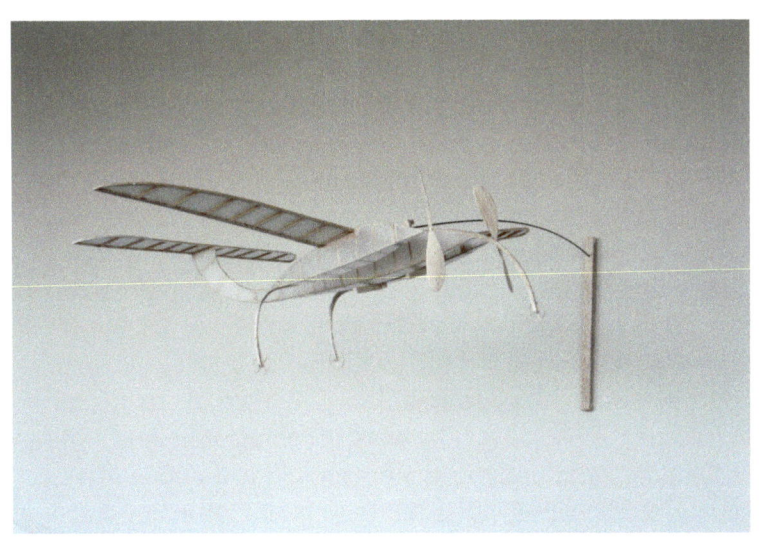

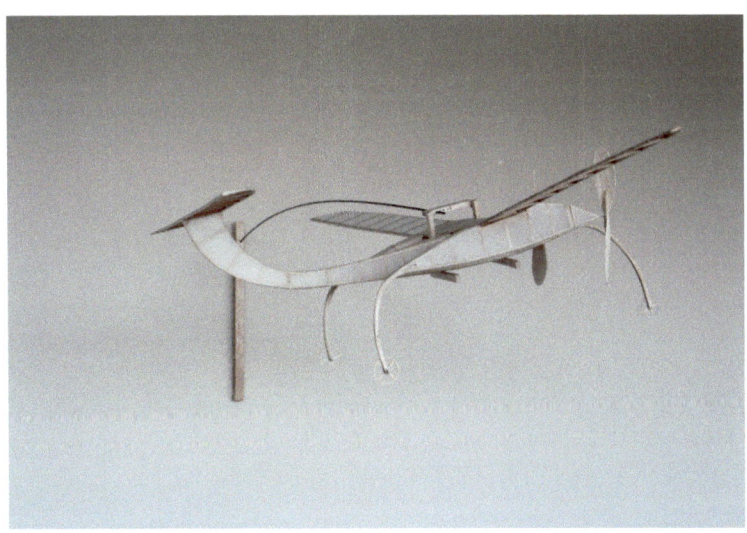

Kids

I once had a vigorous discussion with a friend when he suggested I should give these works away to children. They would get a lot of joy out of them, he said. It seemed to me like such a bad idea at that moment—I spend a lot of effort working on something only to see it break in the unsubtle hands of its recipient? It seemed like a guarantee for disappointment, mine and kids'. But, that was before I learned to love the way that the best-flying works usually fly away, lost forever. And, it was before I had kids. I still don't give my works away to kids, but the idea seems to make more sense now. The works are meant to be temporary, eventually lost. Why should losing one in a tree be any better than losing it to those happy little untrained hands? And, I thought that accidentally crushing a gift would leave a kid, well, crushed, but I have learned that kids—at least my kids—love breaking stuff, including things they really enjoy, even irreparably. So I now think my friend had a great point.

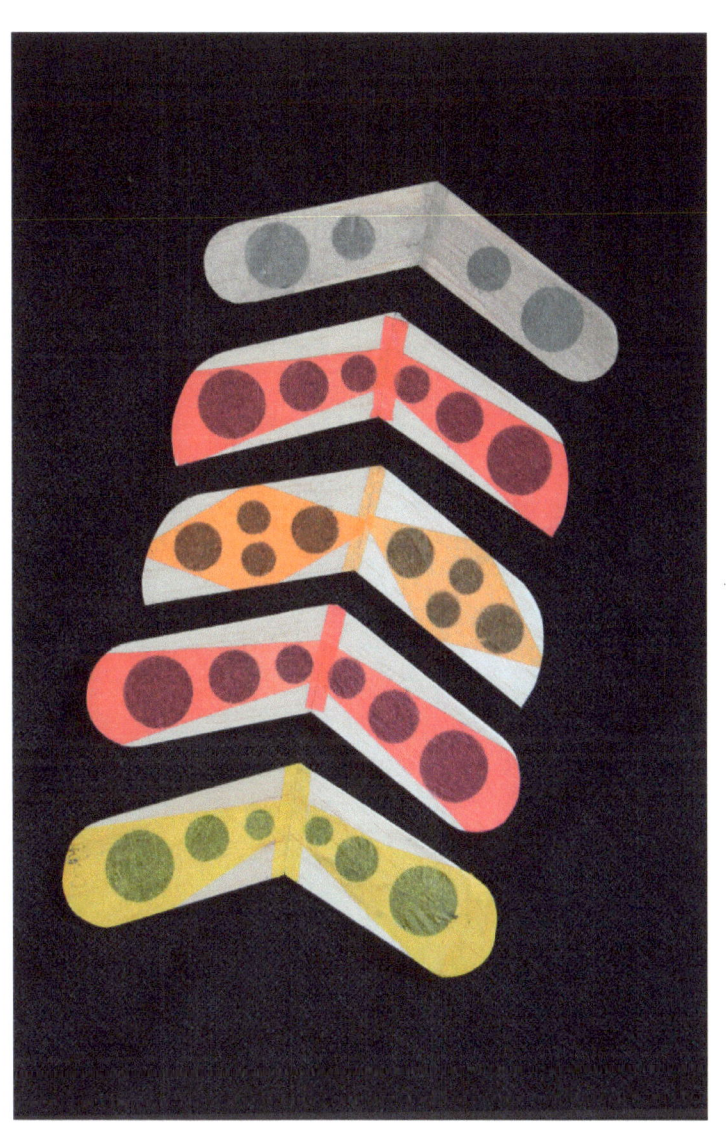

At last

There's no greater luxury in life than enjoying every moment just as it comes. Unfortunately, our society affords few opportunities to do so. I make the works pictured in this book to aspirate attention so completely when in flight, that all the joy and decadence of attending to the present moment seems to burst out of their little wooden frames. It is quite the contrast to life as usual, us worrying and planning as time goes by. How short that time is, we realize, when we take a step back. As short as the flight of one of these works, in the air for a glorious moment under the sun, before it's gone forever.

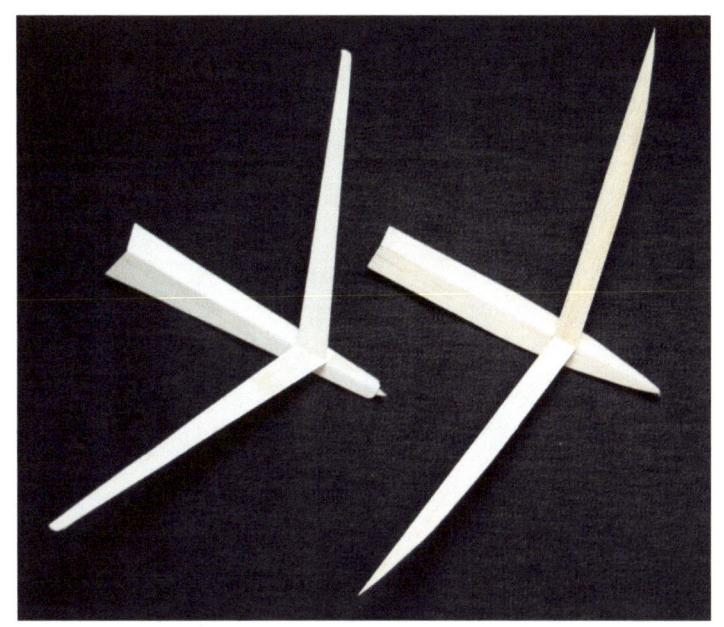

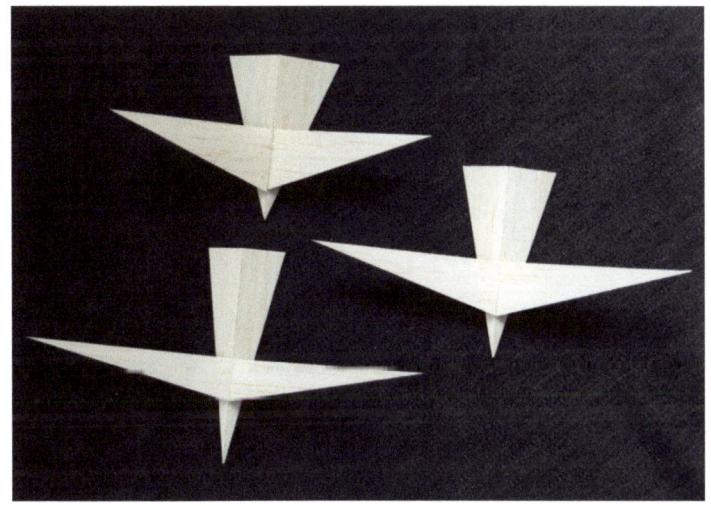

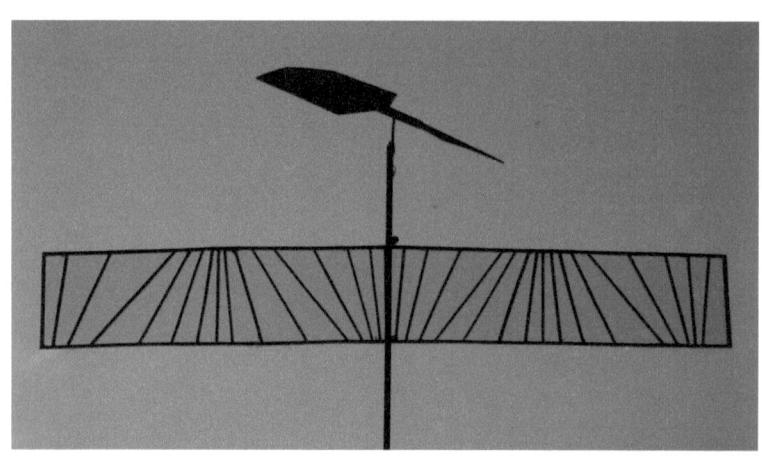

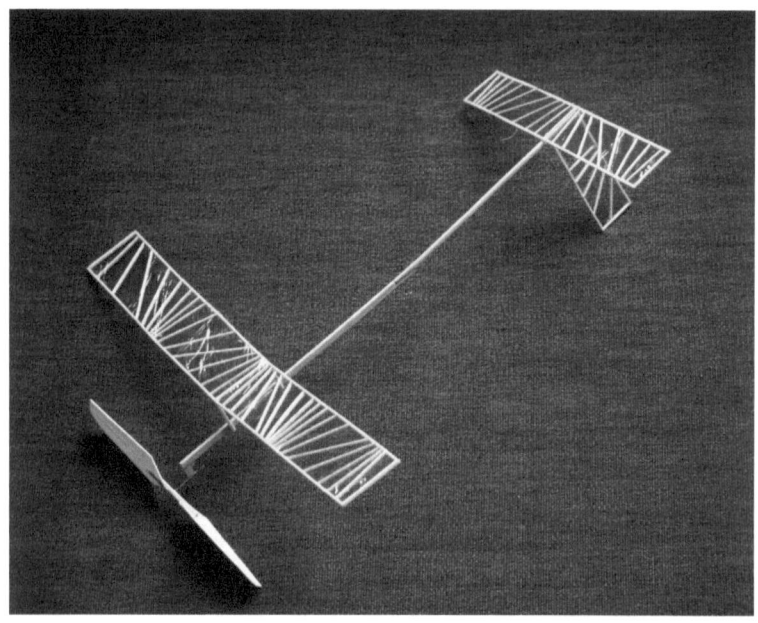

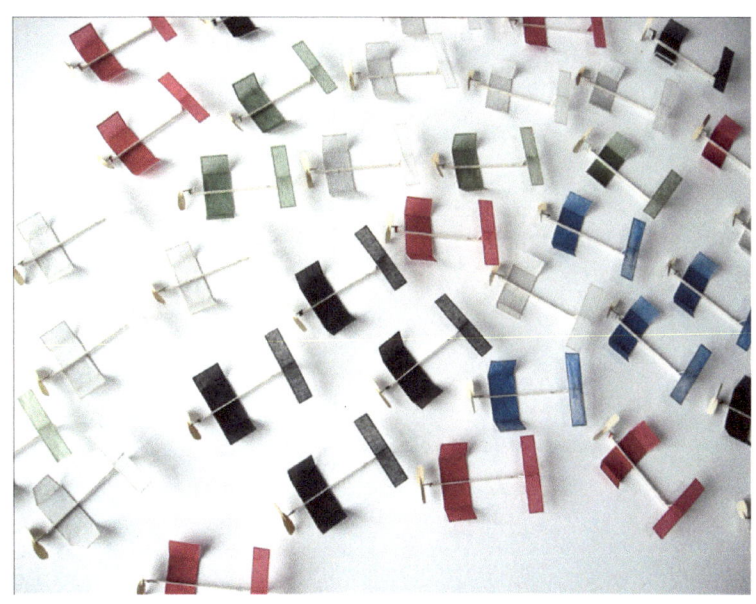
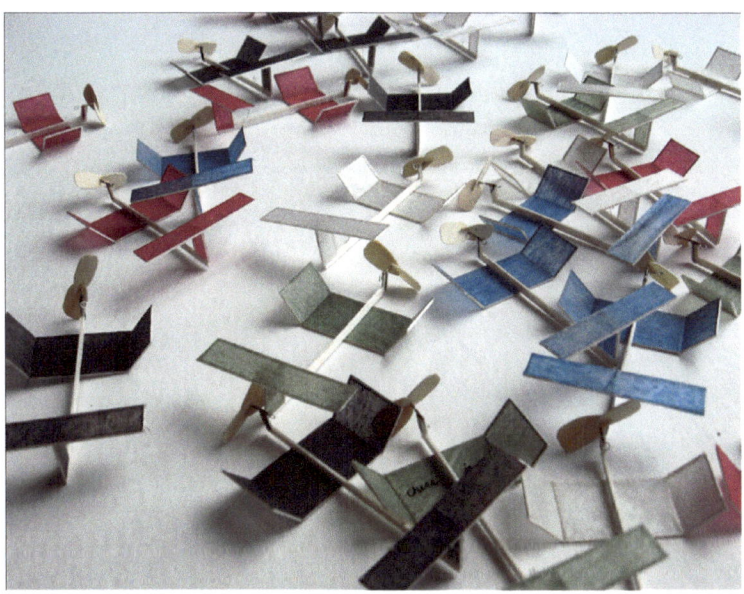

Thank you

I hope you liked spending a bit of time with this book, and I wish you all the best.

Ondrej Mitas (1982)
Bratislava, Slovakia and Breda, Netherlands
ondrejmitas@gmail.com

Notes

Notes

Notes

www.ingramcontent.com/pod-product-compliance
Lightning Source LLC
Chambersburg PA
CBHW041119180526
45172CB00001B/324